Naturally Wild

Naturally Wild

HOW TO PAINT ANIMALS USING SOFT PASTELS

Author/Illustrator/Photographer Julie Lemons
Editors: Cathy Oasheim, Charlotte Endorf, Jesse L. Lemons

Foreword by Jesse L. Lemons

ISBN: 978-1-4907-5390-4 (sc)
 978-1-4907-5391-1 (e)

Library of Congress Control Number: 2015914287

Trafford rev. 09/30/2015

Trafford
PUBLISHING® www.trafford.com

North America & international
toll-free: 1 888 232 4444 (USA & Canada)
fax: 812 355 4082

DEDICATION

For my husband, parents, family and friends whom have encouraged and supported me throughout this adventure. I thank God for this gift of art He has provided to me. It gives me great joy to have the opportunity to share my life joys and art with others. I am especially grateful for the opportunity of painting Sampson, the mountain lion of the David Traylor Zoo of Emporia, Kansas and to Jesse the giraffe, of the Topeka Zoo, Topeka, Kansas, as they both passed away during the writing of this book.

"The words 'try and believe' are actions of the mind and heart for a new beginning." -Julie Lemons

FOREWORD:

I have been acquainted with Julie Lemons (my wife) since she was 14 years old. She has always been involved in the arts, since she was very young. From drawing on the walls, and the backs of furniture, and finally to working her way up to coloring books, her creativity started early. She is constantly improving her work, and looks for critique of her art, so she may improve. She has been a member of Noyes Art Gallery for over 12 years. The most recent offices held are president of ANAC (The Association of Nebraska Art Clubs), president of Lincoln Artist Guild for three plus years, and President of Nebraska Mother's Association of Nebraska, thru American Mothers, Inc.®

Julie, is a very giving person, donating her time and art to Girl Scouts of America, Alzheimer's Association, Nebraska Cancer Society, and The Friendship Home. Julie is a graduate of Doane College, with a Bachelor's Degree in Graphic Design, attaining honors such as Alumni Senior Award, Pinnacle Honor Society, and cum laude academic achievement. She is a very accomplished artist, with her work being sold around the world, in such places as Argentina and Germany. Her work was recently exhibited at the Nebraska Governor's residence in April and May of 2015.

This book is an important adventure for her to accomplish. She loves to share her artwork to inspire and encourage others around her to succeed. If you were to ask Julie where she gets her talent, she will tell you it is a gift from God, as she expresses this in her inspirational, faith based paintings. –Jesse L. Lemons

PREFACE:

Hopefully, you will enjoy this instructional, visual, and conversational book. It has been on my heart to create this book, as it has been a work in progress for over six years. I started taking photos of various stages of my artwork with a dream of producing an instructional art book. All the works of art are originally created from these photos I have taken, while visiting zoos and aquariums. The domestic animals are from my own photos or original photos provided from my art patrons to create their commissioned pieces. The book is not meant to be in depth, but to highlight the steps taken and to inspire others to try painting with pastels. I use a variety of soft pastels. The pastel pencils are usually the hardest of the pastels. The longer, more narrow pastels sticks are the next softest. The shorter round, oval or square pastels are usually the softest. Sometimes the more expensive brands on the market are super soft and seem to melt like butter. They are usually better to use for the top layers of the painting. I use Strathmore ® papers, and suede mat boards for my choice of surface. I have recently been introduced to premium sanded paper and was delighted with the results. It is always good to experiment with new surfaces.

I want to share my joy of painting, love of animals and nature with others. Soon, I want to take it to another level by personally providing art demonstrations at the zoos and aquariums represented in this book. In the future, I will share the coloring pages I have created with children and adults during my "how to paint wild animals using soft pastels" demonstrations.

ACKNOWLEDGMENTS:

I have much gratitude for the encouragement, be it through words, prayers,
donations, or art patronage from the following people in my life:

Jesse L. Lemons

Betty and Lloyd Hubbard

Christophe and Jennifer Hougbenou (Smokey)

D'Wayne & Lora Hubbard

Dan & Janine Hubbard

Laura Beihl

Barb Patronsky

Pastor Pringle

Keith and Marlene Mowry

The Lincoln 55+ Senior Publication, Publisher (Colonel Bourbon)

Vajgrt Family (Baylee and Tate)

Doane College-Lincoln Campus Staff

Barb Faro, Strathmore Artist Papers™ a division of Pacon Corporation

Robin A. Rubemeyer-Creager

Fawn Moser

Lisa Keith

Arden Richardson

I thank Cathy Oasheim (main editor), Charlotte Endorf and Jesse Lemons
for their time and professionalism while also editing this book.

Strathmore Artist Papers™
A division of Pacon Corporation

™ used under license from Mohawk Fine Papers Inc.

Table of Contents

INTRODUCTION:

Welcome! The joy of this book is "how to paint animals using chalk pastels." The painting on the cover is of a leopard name "Mikula" whom lives at the Lincoln Children's Zoo in Lincoln, Nebraska. You will find more information about Mikula further in this book.

Whether you are going to enjoy this book for the pictures or for learning, I appreciate your interest and support. I will list items you may need to create your own animal art, if you would like to try your hand at using pastels. The content of this book starts at the beginning of the first chapter with a list of supplies. With each animal section, you will find explanations on how to use the pastels and supplies.

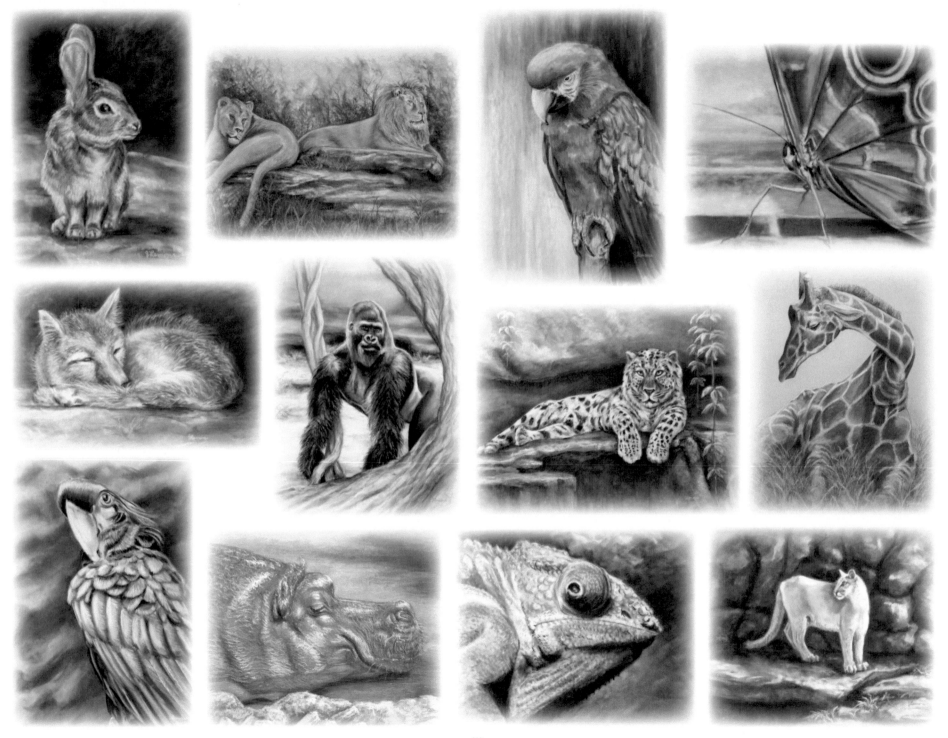

Supplies Needed for a Great Art Experience:

Start with a smile and an idea of something you want to create!

- Photograph you have taken of a wild animal, large enough to see details

- Soft pastels of varying colors and degree of softness, including pastel pencils

- Soft paintbrushes (preferably 1/4" and 1" brushes)

- Pastel paper/mat board/suede board (various colors, preferably 16"x20"), sketch pad (9"x12")

- Wear old clothes

- Rags/paper towels/moist wipes (work great)

- Kneaded eraser

- Unscented hair spray or fixative

- Mask to cover mouth and nose (dust from pastels)

- Non-latex type gloves

- Aluminum foil

PASTELS: One set of soft pastels includes pastel pencils, medium soft pastel sticks and soft pastel sticks. There are many brands of chalk pastels in varying degrees of softness. A set of 24 to 48 pastels would offer a good assortment. If you're just getting started, buy a set of half-sticks or split a set with another artist. This is a frugal way to get more colors at a more reasonable price. Start with a wide range of degrees of soft pastels, with pencils being the hardest to very soft pastels. Pastel pencils are helpful for sketching in the beginning of the piece and for final details. Prismacolor NuPastel pastels are a middle range of softness and one of my favorites. Softer pastels are better for laying on top for final applications.

PAPER/MAT BOARD/SUEDE BOARD/SKETCH PAD: You need a paper designed to hold the pastel. Buy a sketch tablet and pastel paper/board in the size you are comfortable working on. My personal preference is 16"x20" or larger and I keep a variety of paper/mat colors on hand. It is up to you what your comfort level is with size and colors you may use. I prefer using acid free suede board or Strathmore ® products. Start journaling in a small sketchpad and keep it with you. Then you would be able to sketch it when an idea pops into your brain or you see something you wish you could paint. It is good practice, too.

Strathmore Artist Papers™

A division of Pacon Corporation

™ used under license from Mohawk Fine Papers Inc.

PAINT BRUSHES: Paintbrushes are for smoothing and blending the pastels. Sometimes if the applied chalk is too harsh or rigid, you can use a dry paintbrush to soften edges. It also can be used lift some unwanted loose chalk from your painting.

OLD CLOTHES AND BABY WIPES: These are to protect your clothing. Pastels are an almost pure form of color pigment and can be hard to remove from clothing. Be sure to wear old clothing or an apron of some sort. Baby wipes or some type of moist cloths are great for cleaning the chalk off of your hands.

KNEADED ERASER: A kneaded eraser is helpful in lifting up some of the chalk, especially in the beginning.

UNSCENTED HAIR SPRAY OR FIXATIVE: The sprays are for holding the pastel on the surface as the chalk can loosen over time. Flakes of the pastels can fall off the painting if moved around a lot. The spray can also offer a very think layer of textured surface for adding more pastel strokes. However, there are pros and cons for either the unscented hair spray or the fixative. The fixative holds real well, but causes the paper/matt to absorb the pastel more and fades the highlights. Thus, you may have to do it two or three times, i.e.–Highlight.–Spray.– Highlight.–Spray, etc. This can be frustrating, as you have to reapply the pastels over and over, and can lose the spontaneous application or freshness of the first strokes. The unscented hair spray tends to work just as well and does not fade the highlights as much as the fixative. In my 20 years of using pastels, I have not noticed yellowing from the fixative or hair spray.

FACE MASK AND NON-LATEX GLOVES: If you are allergic to air irritants or dust, you may want to get a small face mask. It is always good to use them for your protection.

ALUMINUM FOIL: This is used to create a catchall for the pastel dust that falls from the painting as you work. You can see how I use it in the "Mikula" leopard and "Restful Joy" giraffe sections.

Mikula

This magnificent Amur leopard, Mikula lives in the Lincoln Children's Zoo located in Lincoln, Nebraska. The few that exist in the wild are found in remote parts of the China/Russia border called the Amur River Valley, the mountains of Northeast China, Ussuri River Valley across the China-North Korea border, and the Korean Peninsula. (3.LCZ)

Step 1: I started with photos I have taken of Mikula. I took plenty of photos before I had enough to combine for a good composition. Mikula was hidden behind a study fence, some plexus glass and many vines.

Step 2: I use suede board for most of my paintings because it holds the pastel well and gives the paintings a soft texture. This is great for animal fur. Pastels are almost pure pigment and have little binding to hold it together. Thus, the colors can be soft or vibrant.

Set up your area with your supplies before starting. Spraying with a fixative or non-scented hair spray to hold the chalk is important.

Caution: Be careful, and do not over spray or get the pastels too wet. Spray lightly. Spray at least two feet from your painting. Practice on a scrap piece first. Spray in a ventilated space because it is important to protect your health.

Step 3: Now, we want to sketch the outlines of the leopard with light colored pastel pencils on suede board. Hold the pastel stick like a pencil. Use the tip of the pastel to draw the edges.

Step 4: Soft strokes were added over the light sketch. This begins to give the leopard noticeable shapes, such as shapes of the eyes, nose, mouth, and whole body. Notice the aluminum foil below the painting. It is folded to create a "catch" for the chalk dust that falls while painting.

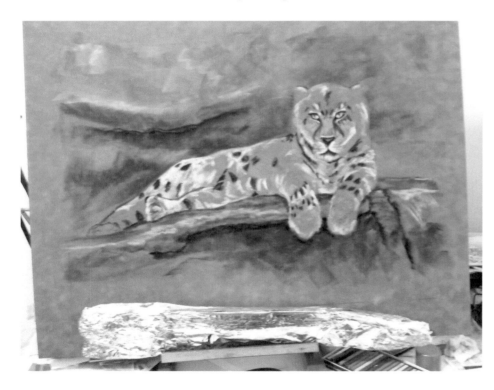
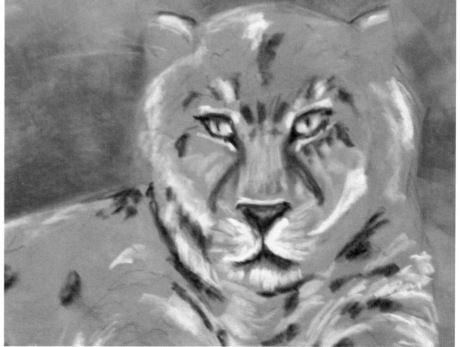

Step 5: Layers of color are applied. The space behind and around the leopard is darkened with a dark brown such as the color burnt umber. Dark greens, grays and burgundy colors are applied blended to create the stones wall and ledge the leopard is reclining upon. Hold the pastel stick in as way that you can use the side of it to apply the chalk and cover more area. Lightly use your fingers or a paintbrush to blend the pastel, by pushing the colors together. I encourage you to try this on a scrap piece of paper or suede board. Lighter colors were added on top of the dark areas to create contrast and the likeness of fur. The texture of the fur is different from the stone/rock area. The fur is soft looking, yet you need to see textured strokes of some of the fur to make it convincing. The stone and rock area need to have a smooth textured look. Yes, it is a visual thing to be able to tell the difference between the surfaces.

Step 6: Notice the added detail of the leopard's spots as we go along. I spray with fixative or unscented hair spray between layering. This creates a more gritty surface for the pastels to adhere. Vines are then added on top as another layer. You can see the details of the leopard's eyes and the texture of his fur. Notice the softness combination of the pastel and suede board. It gives this piece a much softer appeal.

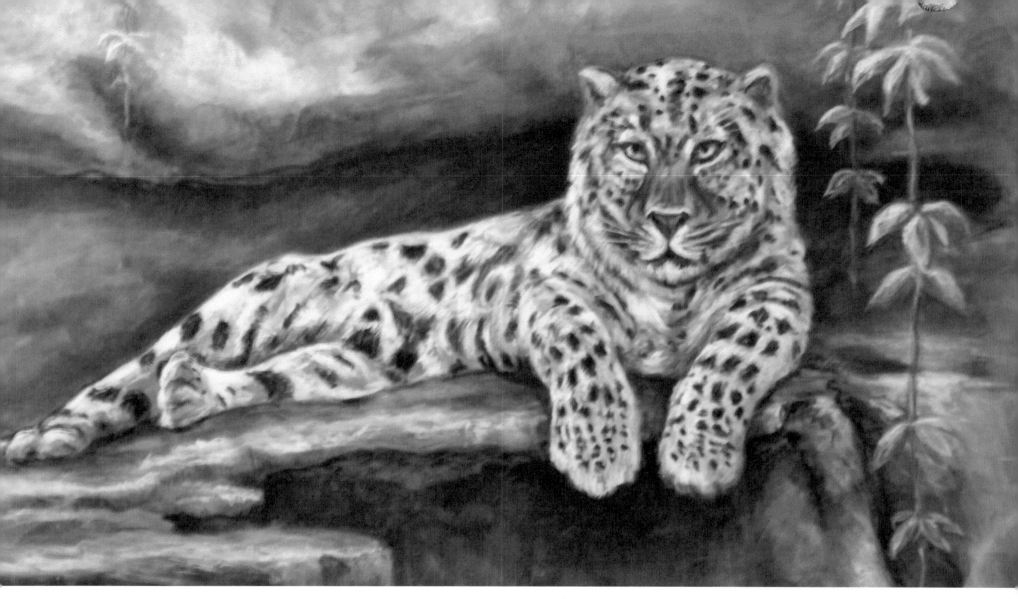

Mikula is a beautiful leopard.

When I took the photos of Mikula, it was feeding time. He rather preferred to sit and sunbathe than eat. He just looked at the zookeeper. She explained that even though he didn't come to get the food, he is still very much a wild animal. She went into a double-gated area that kept her separated from Mikula. She placed the food and left it for him.

Zuri and Avus

Zuri and Avus are African lions that live in the Topeka Zoo in Kansas. The Lions Pride opened in 1989. Zuri and Avus also have another lion in their pride named Asante. (5.TZ) The photo used for this drawing was taken from a long distance. You can see some of the obstacles in the way and the details are not real clear, making this painting more of a challenge.

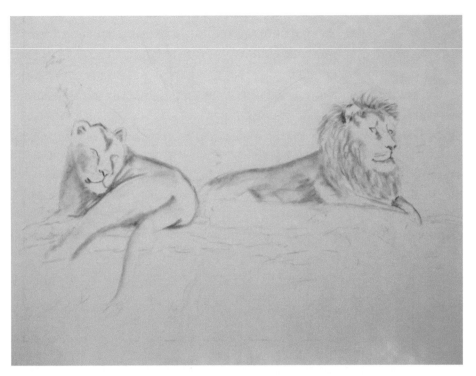

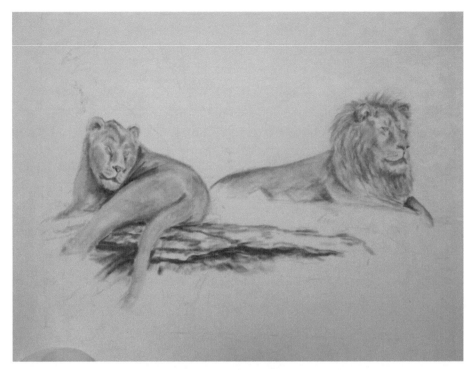

Step 1: Start with sketching softly with grays and brown toned pastel pencils. Look at the shapes of the lion and lioness. There are many oval, curved and rounded shapes. You don't have to know how to draw a straight line!

Step 2: Notice here how various colors block/fill in certain areas. I used colors such as Burnt Siena, Raw Siena on the lions. It is like coloring in a coloring book. Now, fill in the shapes with more of a golden yellow color. Begin drawing in shapes of the slab rocks underneath the lions using a medium gray. Focus on the shapes and then fill in with lighter gray tones. You can add darker grays back onto the painting to create shadows on the slab rocks. Use your fingers or 1/4" paint brush to blend the chalk.

Step 3: Background colors of gray, dark burgundy, and dark green are now added to provide dark contrast behind the bodies of the lion and lioness to create contrast. This will be what is called the 'under painting' for the foliage in the background. Under painting is a base color in which you can add more pastel colors on top. This layering allows light colors to show up on top of darker colors, and vice versa.

Step 4: Add some different shades of gray on the rock slabs. As we add other colors such as lighter greens in the background and foreground, it adds more depth. I always apply the colors throughout the painting to pull it together. The colors need to flow throughout the whole painting. No individual color should be isolated from the rest of the colors in the painting. All the colors need to give the viewer a visual feeling of 'all colors connect'.

One thing I have learned from painting this piece is that I needed to rearrange the composition/layout. An artist needs to arrange the objects in a painting so the viewer will keep their eyes looking within the painting and not 'off the page.' In this piece, it might have been better to overlap the lion and lioness, moving the female more in front of the male. I could have also allowed more space in front of the male lion. With the lion too close to the right edge, it causes your eyes to leave the painting on that side instead of visually staying within the painting. You do not have to always paint exactly what you see. I eliminated the back right paw of the male lion because it did not come across visually appealing. Please see the painting in Step 4, as the back paw of the lion is visible. You will not see the paw in the final piece. The paw is covered up with dark gray. A few layers of lighter gray and browns where added on top of the dark gray.

Avus and Zuri make a beautiful pair. One more lioness lives in the Topeka Zoo.

Topeka Zoological Park

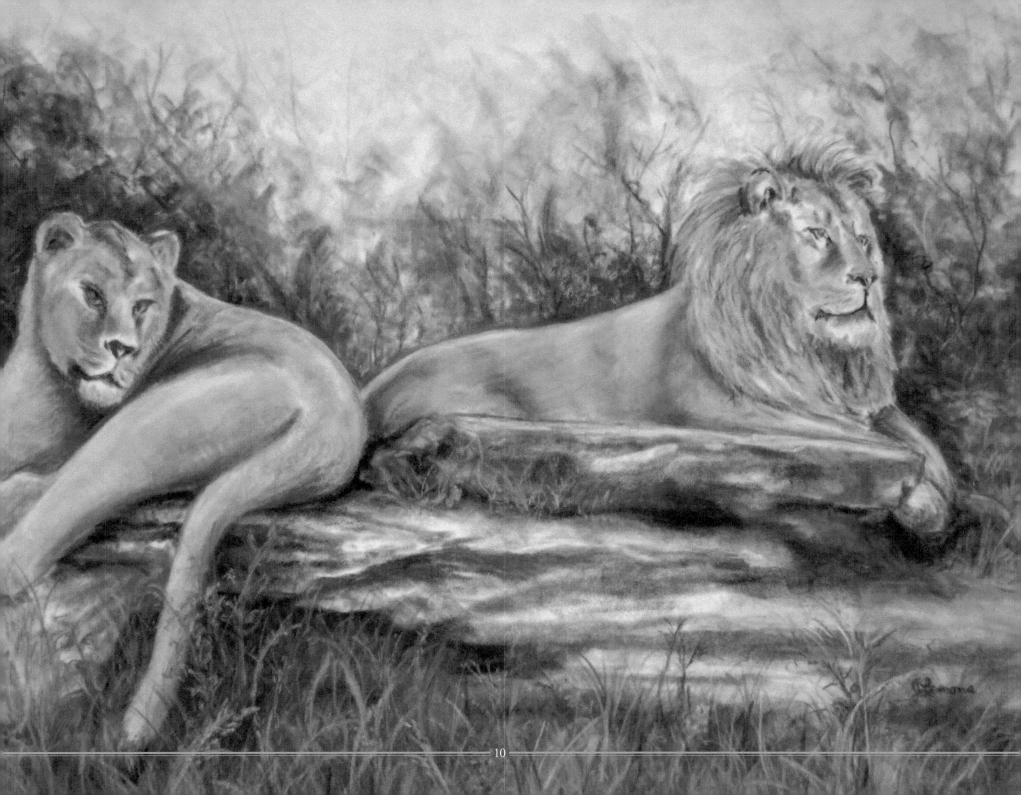

Sampson

Sampson, the mountain lion lived in the David Traylor Zoo of Emporia, Kansas. Sampson lived to be 16 years old in captivity.

Sampson arrived at the Zoo in 1998, as an orphan from Wyoming and quickly became a favorite for Zoo visitors. It was not unusual to see Sampson lounging in his cave at the front of his exhibit watching visitors pass by or spending time up in his tree overseeing the entire Zoo. (2. DTZE).

Step 1: This sketch is created with dark colors (burgundy and black) to form shapes and shadows on the boulders and the mountain lion. The surface is a gray suede board. Lighter colors were used to provide contrast on the boulders and mountain lion.

Step 2: More highlights are created using lighter colors such as a cream and light brown. Notice how the burgundy color is used to make shadows. The rotation of the chalk pastel colors from dark to light and light to dark, are used while spraying lightly with the fixative. This process provides a textured surface for layering.

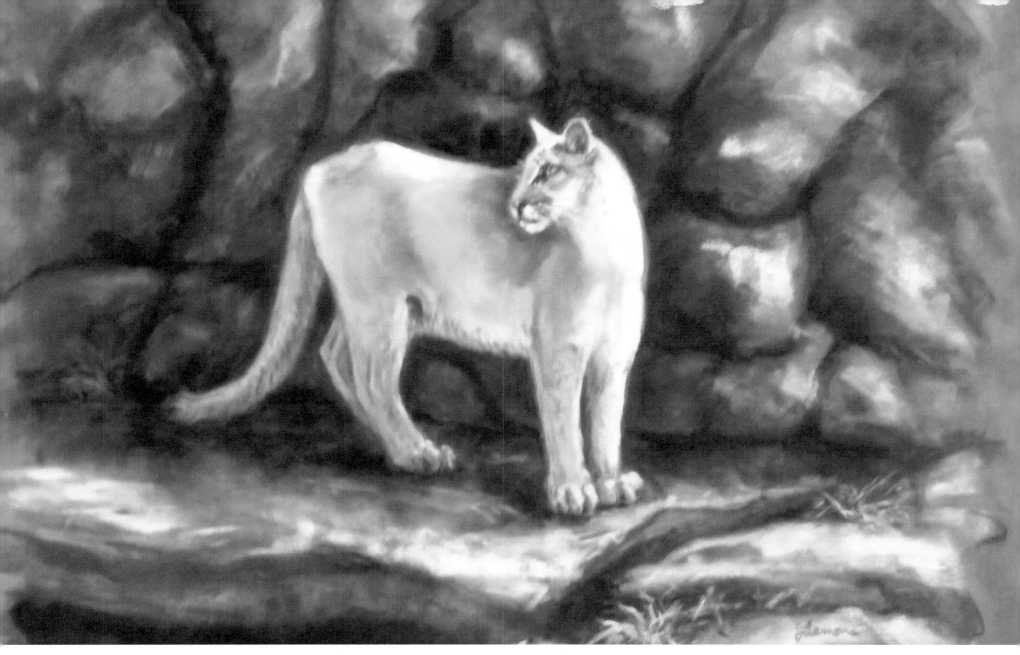

Step 3: The top layers consist of lighter colors such as gold, tan and white for highlights to complete the painting. Sprays of grass are coming up between the rocks. The grass is created using long strokes of green and brown colors.

What a magnificent mountain lion!

Young Fox Resting

This young Kit Fox is in the Omaha's Henry Doorly Zoo and Aquarium, Omaha, Nebraska (4.OHDZA). You can find him in the desert climate at the zoo.

The small Kit Fox was high up on a ledge, so I had to get on my tippy toes, hold my camera as high as I could reach, in order to take this photo. It was really worth it, because I was able to view him at eye level instead of at an angle.

In this piece, the fox is displayed before the details of the fur were added. The colors of reds, medium/light grays and some lavender colors are applied to serve as an under painting.

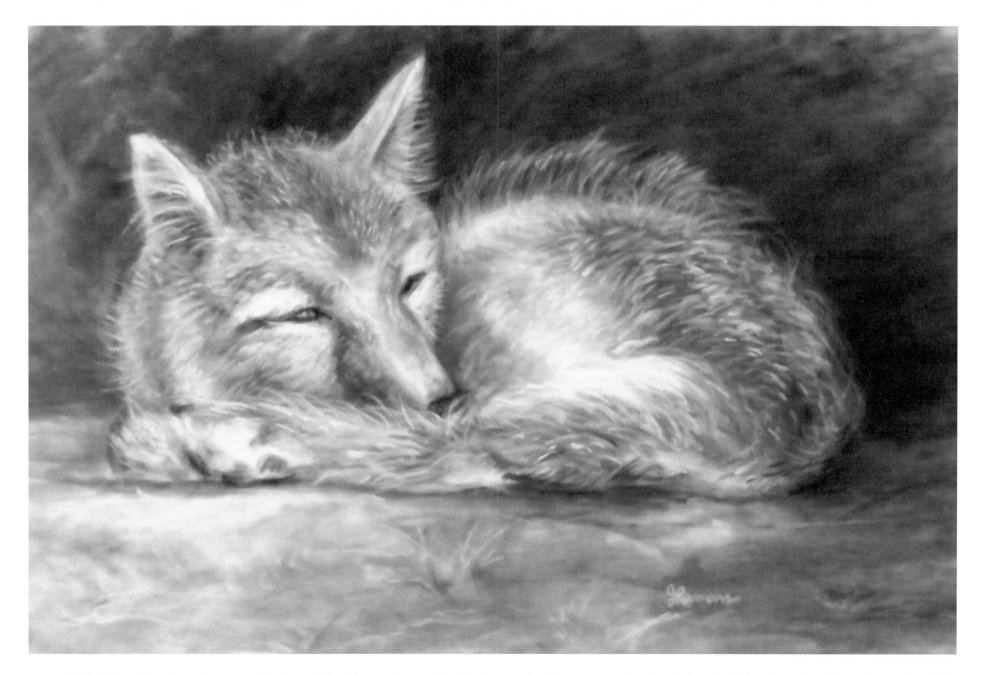

Next, the lightly colored strokes are applied carefully. The strokes need to be thin so the fur appears soft. The dark value behind the fox allows the stroke of the fur to stand out in contrast. See how the fur stands up on its back? I wonder if he is as soft as he looks?

Restful Joy

Jesse the giraffe resting in the Topeka, Zoo, Kansas. (5.TZ)

Step 1: You guessed it! The sketch comes first! This time, the painting is drawn on a light brownish mat board with very little texture to hold the pastel chalk. Spray more often between layers of color.

Step 2: Medium value of color is added as the under painting. Darker values are added for shadows by using a darker brown. Spraying with fixative or a non-scented aerosol spray is used to set the pastel. This is done in a well-ventilated room or outside. This creates some texture that works as another layer.

Step 3: Details of the fur, eyes/lashes, ears, and mane are carefully applied. Short and carefully applied strokes are important. This takes practice and patience.

Step 4: The grassy area is painted with short angled strokes of various greens, browns, white and gold colors in the foreground and around the sides of the giraffe. The giraffe then looks like he is lying in the grass.

This peaceful animal may be well camouflaged due to its fur color and patterns. Notice use of the aluminum foil below the artwork. This catches some the chalk that falls as you paint.

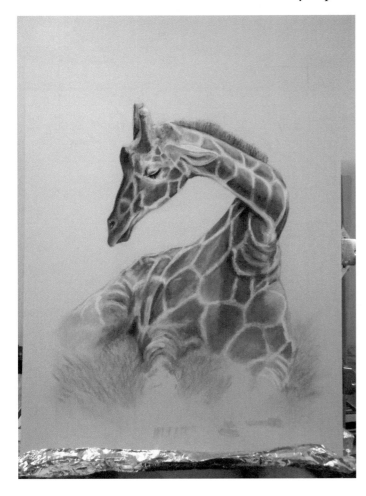

The Topeka Zoo has scheduled dates and times visitors can get up close to the giraffes. (http://topekazoo.org/events-activities/giraffe-feeding/) It is an amazing experience to observe these fascinating animals! (5.TZ)

Topeka Zoological Park

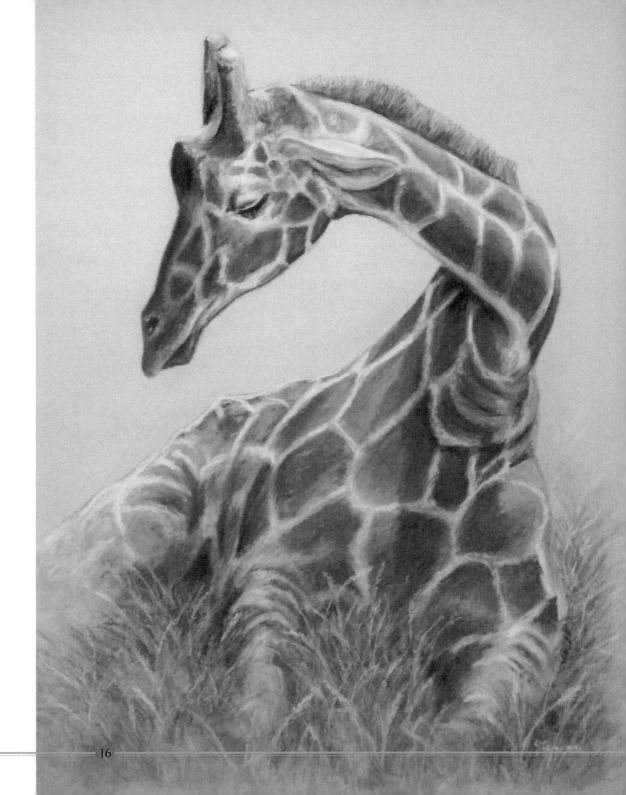

The Sunbather

This Nile River hippopotamus was sun bathing in the Topeka Zoo, located in Topeka, Kansas. His name is Vision. (4.TZ)

Step 1-4: The first illustration is the actual photo of the hippopotamus. He was "sunbathing" in the outdoor pool of water.

In the second thru the fourth illustrations, you can see how the color was built up from light to dark with lighter colors applied on each layer. I went from light to dark to lighter highlights for the layering. This piece was painted on a gray mat board. This painting is now in a private collection.

The sketch is not shown here, but you will need to draw a sketch of the painting with a pastel pencil before you add the under painting. In this painting, you will go back and forth from dark to light and light to dark to complete the painting. Light colored chalk, such as light grays and light reds, is used on top of the darker colors,.

Darker layers of color were added here as I drew a little too light with the strokes. I went a little too far with the highlights. It was necessary to add dark shadows.

It is time for more highlights. Apply the whiskers carefully with long angled strokes. The top strokes help to illustrate the depth of the water, and the whiskers to be more noticeable.

Topeka Zoological Park

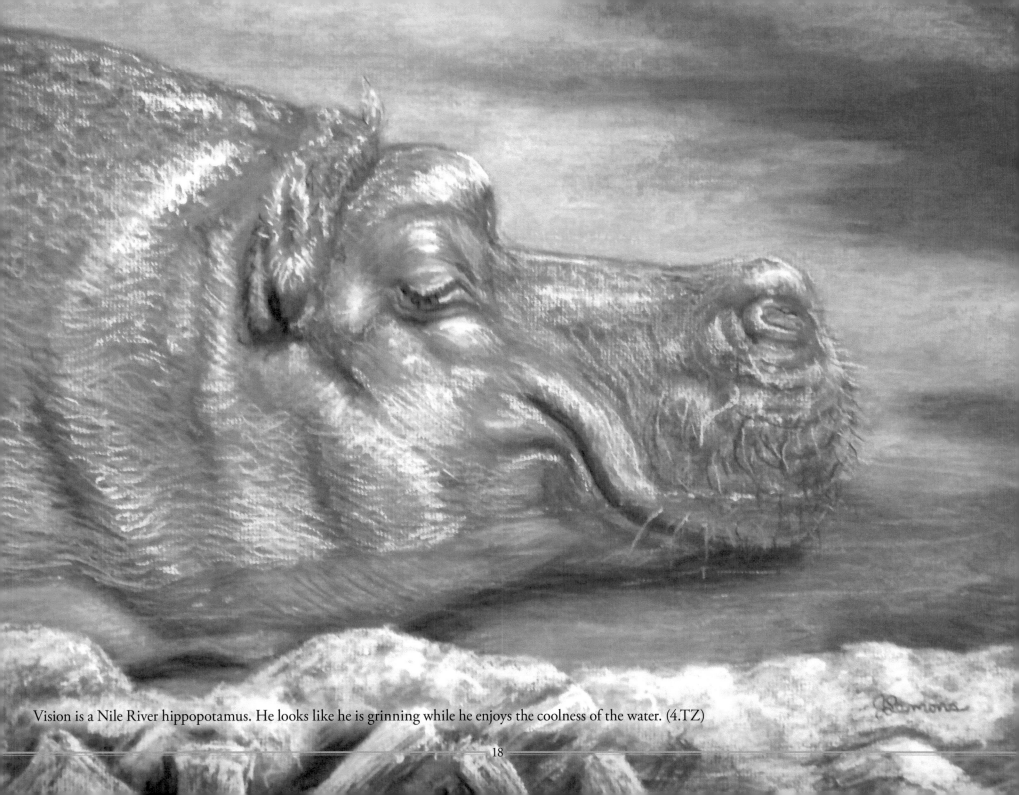

Vision is a Nile River hippopotamus. He looks like he is grinning while he enjoys the coolness of the water. (4.TZ)

The Protector

Step 1:
This silver back gorilla lives in the Omaha's Henry Doorly Zoo and Aquarium (Hubbard Gorilla Valley)

Step 2:
The painting starts with a light sketch and medium tones for the under painting. Looking at the gorilla's hair, you can see other colors besides black. These colors are partially covered up later in the painting. This helps to give the hair some depth. Beige colored suede board was used for this painting.

Step 3:
In this step, other objects were added such as the tree and some background. I made the decision to move the gorilla's right arm forward.

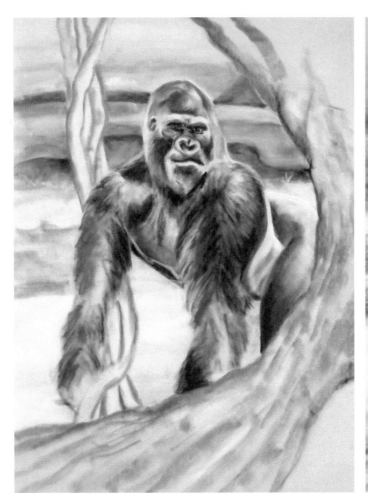

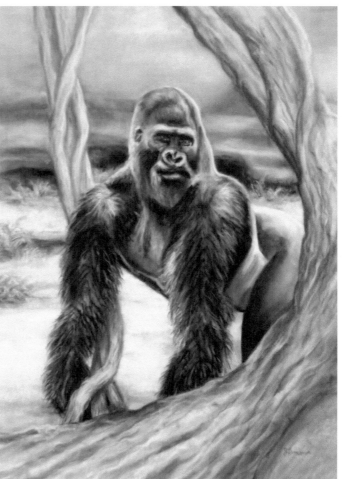

Step 4: Moving the gorilla's arm over the intertwined vines helps to make the gorilla seem as if he is moving thru the area between the vines and the tree. Charcoal gray and black were added for the shadows on the gorilla. The bark texture on the tree is added by using wavy short and long strokes of various colors (mostly browns, white, grays and tan).

Step 5: Layers of spray, light and dark pastels were added. Lavender is softly applied in areas for shading and background to help the depth of the painting.

The gorillas move around freely in the Hubbard Gorilla Valley Complex at the Omaha's Henry Doorly Zoo and Aquarium. Even though my maiden name is Hubbard, I cannot claim contributions to the wonderful facility. I can visit and enjoy the wonders of these animals.

Scarlet's Post

Step 1: You will find this brightly colored Scarlet macaw at the Omaha's Henry Doorly Zoo and Aquarium, located in Omaha, Nebraska. (3. OHDZA)
The original photo of the macaw is shown here.

The macaw is sketched on cream suede board using raw umber and burgundy chalk sticks.

Step 2: Adding color is fun! I started with the brightest red in my pastel box, and then applied a lighter orange to the painting.

Step 3: Choppy strokes of red, violet and orange add texture to the feathers. Contrasting greens with some blues in the background are created with downward strokes. This helps resemble the foliage hanging behind the macaw.

Step 4: When drawing or painting animals or people, look close at the subject for details. Pay attention to other colors that are in the hair, fur, nails, and skin. In this case, we are painting feathers.

As we look closer, we see the colors violet, gray, yellow and tan on the macaws face and claws. From a distance, you may not notice these colors. The same colors are blended into the feathers of the macaw. Using these colors throughout the painting helps to pull it all together. This will help keep the viewer's eyes focused within the painting.

I chose to leave the background less detailed so it would not distract from the macaw. This painting is created using beige suede board.

Look at the details. The shadows under the claws help the claws look on top of the post.

There were several Scarlet Macaws at the zoo, but he seems more stately his primary colors of red, blue and yellow.

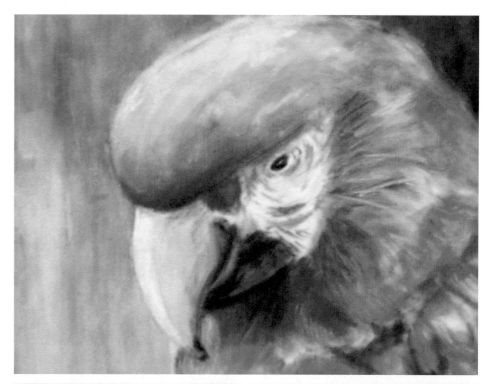

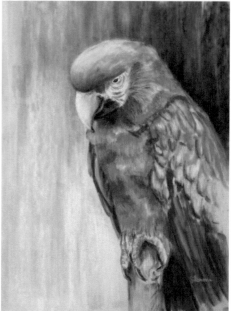

CHAPTER 10

Coat of Blue

This handsome Hyacinth macaw lives in the Dallas World Aquarium, located in Dallas, Texas. (5. DWA)

The contrast of the blue feathers against the tan rock wall is eye catching in this original photo.

Our steps begin again with a sketch. This time, I chose a deep blue chalk pastel to outline the macaw.

Lighter blues, reds and medium brown pastels are used to create the rock wall background and feathers.

Circular movement while holding the chalk on its side can help create the smoothness needed to create the rock wall.

White chalk is added on top, to highlight the feathers and gleam in its eye.

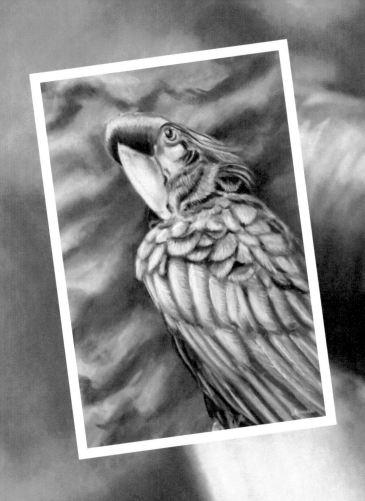

This Hyacinth macaw looks so handsome in his 'coat of blue.'

Liz is looking at you!

Liz, is a chameleon and lives in the Dallas World Aquarium in Dallas, Texas.

Chameleons have the capability of changing their outward appearance by matching the color of the surface they rest upon. 5.DWA)

Step 1: Study the original photo of the chameleon. Look at the different shapes. Do you see a triangle within a triangle? Liz's head shape is like a triangle. Do you see a circle inside a circle? That would be Liz's eye. Use light colored suede board or perhaps some . Begin drawing shapes, such as the circles for the eye. Start adding a grayish-green color using short and medium strokes.

Step 2: Add under painting, darker values to lighter values in the background. Be sure to notice the void space or the light space. This is a good contrast area for the chameleon. This painting was built from rotation of light and dark adding shadows, followed with lighter colors for highlights. Dark greenish blue, light bright orange, and a medium brown are used in the background.

Step 3: Details are completed in this step. Rotation of spraying and adding highlights is done two times with each layer. Spray and apply light off white. Spray. Apply light off white.

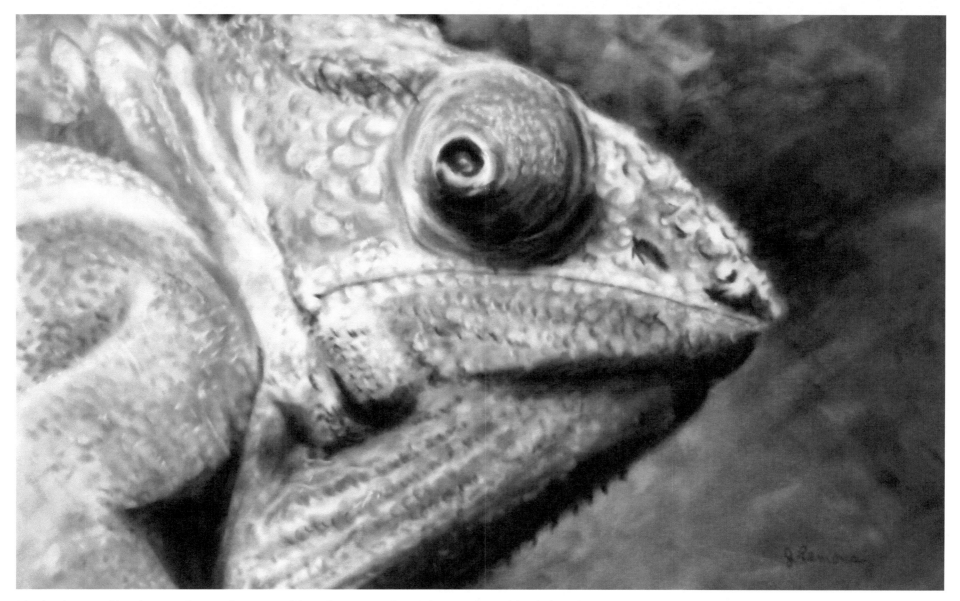

The background has layers of green, brown, gold, and orange colors. The pastels are blended with a 1/2 inch brush (lightly move the brush or your fingers back and forth to soften the look). Add finishing touches, such as adding the bumps under the neck and darken for more contrast.

It is amazing how the chameleon can change color to protect himself from danger by blending in to his surroundings. My son had a small chameleon when he was little. It was fascinating to see the chameleon do its 'thing' and change colors.

Lil' Jax

Lil' Jax is the name I gave the young jackrabbit as I created the painting. The rabbit lives in the Omaha's Henry Doorly Zoo and Aquarium, located in Omaha, Nebraska. (3. OHDZA)

As you can see in the photo, the rabbit is in a sandy warm climate in the zoo. I chose a gray suede board for surface of this painting. It allowed some of the grays to show through in areas to create a sandy look.

I remember when I was a child visiting my grandparents' farm in southern Missouri, my dad pointed out a jackrabbit in the wild. He explained they had larger ears than our local cottontail rabbits at home in northern Missouri. In the photo of the rabbit, you can see how his ears look thin with the light coming through causing the veins to show.

Like other paintings in this book, you would start with a light sketch and then start laying down chalk for the under painting. Yes, now look at the shapes in the photo of the rabbit. The ears and head are kind of oval or pear shaped, on its side. The eye is really round with an outer oval or almond shape around it. The nose shape looks like the letters "Y" or "V" (you choose) and the legs look a little like chicken drumsticks, but furry ones. The body is also pear shaped. Keep the shapes in mind as you look at the rabbit.

In the next photo, the shapes are outlined and labeled. When you sketch the shapes, use one color such as light brown. The shapes will overlap and it is okay. You will be adding layers chalk that will cover unwanted lines.

For the eye, make a circle filling it in with black and with a touch of dark blue. Use a light brown to create an almond shape around the eye.

Ears: oval, pear shaped

Eyes: circle with an almond shape arount it

Head: oval, pear shaped

Nose: 'Y' shape

Body: oval

Legs: chicken leg shapes

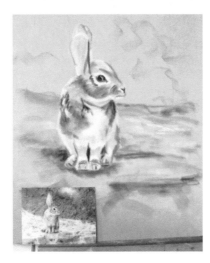

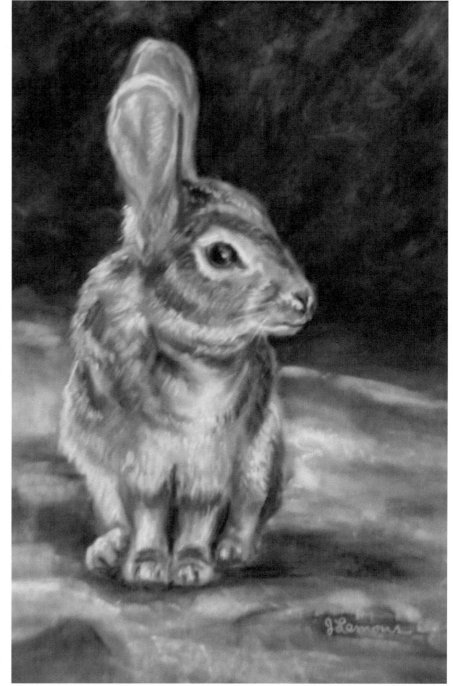

Build up with more color. Add darker chalk (dark browns and blues) behind the shoulders to above the rabbit's head. This will give the painting more contrast and depth. Look where the shadows are on the rabbit. Use some of the same dark browns used in the background to create the rabbit's shadows, such as on the shoulders, under the jaw below the light fur, between the legs, on the right side you see of the thigh, and under the feet. At this point, you are still creating some under painting so you can layer the fur. Using short strokes, gently apply the lighter (off white or cream color) strokes of the fur on the body, jaw, chin, and over the top part of the legs. Add a medium purple stroke just to the upper part of the eye. Now you may add white or almost white pastel chalk strokes in highlighted areas such the back of the neck and the top edges of the ears.

Next, using gentle short strokes, highlight the lightest areas of the feet, hindquarters, and nose. Highlight some of the ground with light browns, tans, and cream colors, but leave the shadowed areas alone. Now...the last strokes will be long and quick strokes...steady your hand and place the tip of the chalk to the side of the nose where it starts. Look close at the photo to see the details. Then gently bring the chalk stick or pencil to the left across the face with a quick downward move of your hand. You did it!!! Sign your name. Now, check the nozzle of the spray can and spray on a piece of scrap paper. Remember to stand back a couple of feet from the painting so as not to allow drips from the spray. Spray the painting with fixative in a ventilated space.

Beach Beauty

This butterfly was in the Omaha's Henry Doorly Zoo and Aquarium, Berniece Grewcock Butterfly and Insect Pavilion. (3. OHDZA)

Working from my photo of the butterfly, I started with the brown colors of the butterfly we see on the wings. As I continued to work on it, I notice the background looking a bit like clouds, sand, and water. It was actually condensation on the window in which the butterfly landed. I thought it was beautiful, thus Beach Beauty. Allowing imagination to flow adds a little mystery to the art.

The Berniece Grewcock Butterfly and Insect Pavilion is fun to visit at the Omaha's Henry Doorly Zoo and Aquarium. The butterflies are plentiful and they often land on you.

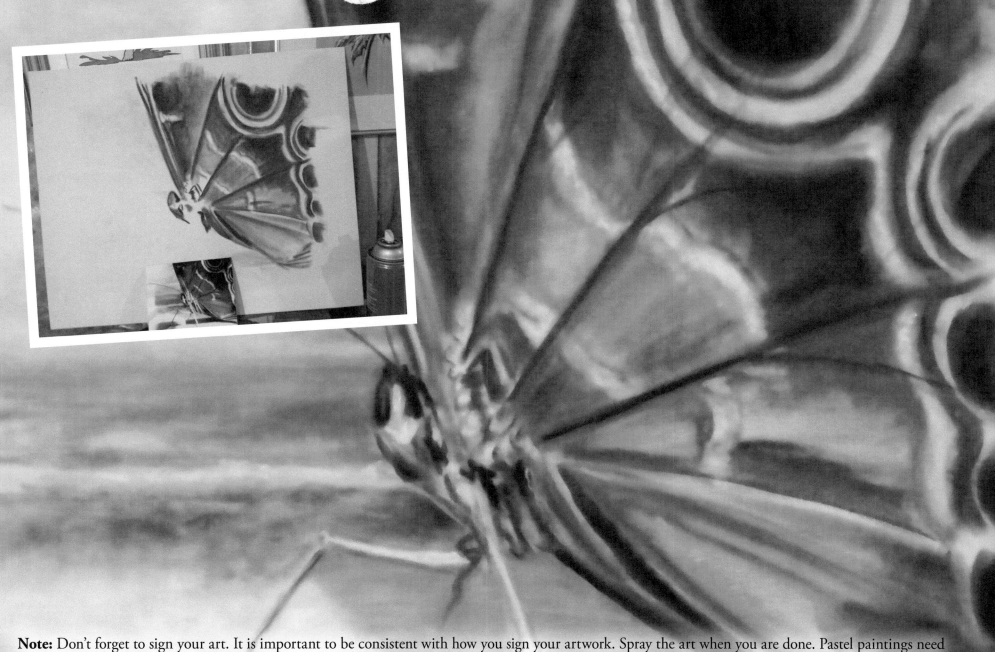

Note: Don't forget to sign your art. It is important to be consistent with how you sign your artwork. Spray the art when you are done. Pastel paintings need to be framed under glass with a spacer such as foam board between the outside mat and the art. Sometimes particles may fall from the pastel paintings over time. The spacer allows the particles to go behind the outer mat instead of on it. No worries, however, because you will see pastel paintings in art museums that were done hundreds of years ago.

Sneak Peek:

PAINTING PETS WITH CHALK PASTELS

Take a look at the following examples of furry friends featured in my next book.

Permission was given by my clients to show these commissioned pieces in this book.

SMOKEY

This kitty is my grand-cat, Smokey! My daughter, Jennifer rescued this lovable guy from the Emporia Animal Shelter in Kansas. I enjoyed painting this beautiful cat.

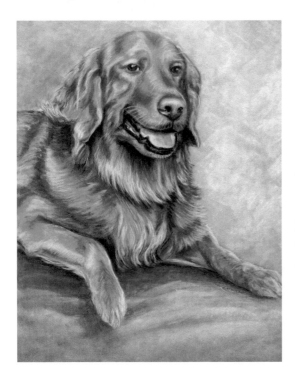

COLONEL BOURBON

This piece was a commission and later printed on the cover of the Lincoln 55+ Senior Publication, Fall 2008 issue. It was an honor to paint this handsome Colonel Bourbon. The original pastel painting is in the private collection of the Lincoln 55+ Senior Publication publishing company in Lincoln, Nebraska. http://www.lincoln55plus.com/

LINCOLN 55+ SENIORS PAPER

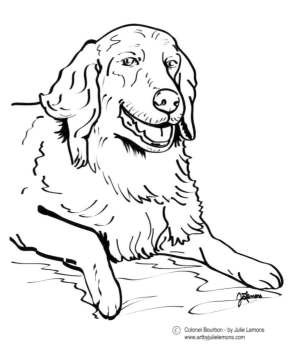

Animal Coloring Page Example

The black and white example is created for a future coloring book to accompany my next book. The goal is to create all the animals in black and white illustrations to match the completed colorful art in the book.

© Colonel Bourbon - by Julie Lemons
www.artbyjulielemons.com

Baylee and Tate

The paintings of these two basset hounds are in the private collection of the Vajgrt Family. They were a joy to paint, as I used to have a little basset named Sadie.

BIBLIOGRAPHY

1. (DWA) Dallas World Aquarium, Dallas, Texas. http://www.dwazoo.com/

2. (DTZE) David Traylor Zoo of Emporia, Emporia, Kansas.
 http://emporiazoo.org/index.php/latest-news/139-sampson

3. (LCZ), Lincoln Children's Zoo, Lincoln, Nebraska.
 http://www.lincolnzoo.org/animals/outside-animals/amur-leopard.html

4. (OHDZA) Omaha's Henry Doorly Zoo and Aquarium, Omaha, Nebraska.
 http://www.omahazoo.com/exhibits/

5. (TZ) Topeka Zoo, Topeka, Kansas. http://topekazoo.org/

SUMMARY

I believe art goes beyond a blank piece of paper and graphite of the first sketch. Happiness starts when the idea and desire to create something new becomes an urge that pushes the creativity. Then the chalk dances on the paper.

"Naturally Wild" is a book designed to show the steps I have taken to create animal paintings from my own photos. The steps start from sketch to the completed painting. This book includes wild and a sneak peek of my next how to paint book of domestic animals. You will find helpful tidbits about the materials and techniques used in the process.

I hope this book, "Naturally Wild" will encourage others to become artists, inspire artists to try something new in art, and reach prospective adoptive parents for animals in shelters and zoos. It is important to me to "give back" sharing time and my art ability with others. I have goals to attend book signing events at the zoos represented in this book. I plan to perform free art demonstrations for children at zoos and animal shelters.

Encouraging others in art and sharing a combination of joys in my life is important. "Naturally Wild" is an inspirational book that may be used as a classroom tool or a conversation piece sitting on a coffee table.

CONCLUSION:

I hope you enjoyed this book. It has been an endeavor I set my heart on to create for many years. Please share the book with your family, friends and inspiring artists.

Spend time with your family sharing the beauty around you. I encourage you to never give up on your passion and do what you enjoy. My goal with this book is to encourage others, especially in visual arts.

ABOUT THE AUTHOR

Julie Lemons, author/illustrator, is involved in local galleries, Lincoln Artists' Guild (past president) and Association of Nebraska Art Clubs (past president). She is a graphic designer for Lincoln Public Schools with 30 years of design experience. Her husband, family and friends are great supporters. Her artwork may be found at Noyes Art Gallery; Lincoln Artists' Guild sponsored shows; permanent collections; and various venues throughout United States, Germany, and Argentina. Julie believes that to be a successful artist, is to allow God's love shine through her art.

She is also the past president of the Nebraska Mothers Association. Helping to strengthen her community, Julie (2010 Nebraska Mother of the Year®), donates time and art to various causes/fund raisers. This includes the Alzheimer's Association-Great Plains Chapter, animal shelters, Friendship Home, Girl Scouts, Heartland Cancer Foundation, Lincoln Public Schools Association of Office Professionals, and church activities. She enjoys exploring life with her family/friends, her kitty, nature walks, going to zoos, swimming, and art.

Julie Lemons:
Born in Kansas, grew up in Missouri, resides in Nebraska.
BA Graphic Design
www.artbyjulielemons.com

Printed in the United States
By Bookmasters